REALLY IMPORTANT STUFF
MY CAT HAS TAUGHT ME

CYNTHIA L. COPELAND

WORKMAN PUBLISHING • NEW YORK

For my favorite cat lovers: Julie, Lindsey, Leslie, and Gabe

As always, I'm deeply grateful for the guidance and wisdom of the best editor in the biz, Margot Herrera. For fifteen years, I've trusted her instincts and welcomed her insights. She always makes my books better. Thank you to my amazing agent Dan Lazar of Writers House, who sealed the deal. And many thanks to those talented folks at Workman who helped with photo research, design, copyediting, and more: Anne Kerman, Michael Di Mascio, Ken Yu, Jean-Marc Troadec, James Williamson, Evan Griffith, and Kim Daly.

Copyright © 2017 by Cynthia L. Copeland

Library of Congress Cataloging-in-Publication Data is available.

ISBN 978-1-5235-0148-9

Cover design by Vaughn Andrews
Interior design by Jean-Marc Troadec

Photo research by Anne Kerman, Michael Di Mascio, and Ken Yu
Front cover photo © Sabine Rath
Back cover photo by Akimasa Harada/500PX

Workman books are available at special discounts when purchased in bulk for premiums and sales promotions as well as for fund-raising or educational use. Special editions or book excerpts can also be created to specification. For details, contact the Special Sales Director at the address below, or send an email to specialmarkets@workman.com.

Workman Publishing Co., Inc.
225 Varick Street
New York, NY 10014-4381
workman.com

WORKMAN is a registered trademark of Workman Publishing Co., Inc.

Printed in China

First printing October 2017

10 9 8 7 6 5 4 3

Contents

A Laugh, a Cuddle, a Tonic

Twelve years ago, my daughter Alex came upon an ad in our local newspaper: A family in a nearby town was trying to find homes for a litter of kittens. We drove to their house (in a blizzard) to find just one kitten left. She had bright blue eyes and was a creamy gray color; the tips of her ears, her feet, and her tail were a shade darker. She was as soft and as fuzzy as a cotton ball. We named her Phoebe.

Phoebe was a spunky kitten, able to hold her own against our enthusiastic yellow lab, obnoxious parrot, and the myriad other creatures that came and went in our house thanks to Alex's sister who was working after school in a pet store. With a right jab that even Muhammad Ali would have envied, Phoebe earned her spot at the top of the animal heap. From the start, she taught us a lot about advocating for ourselves. She's made a habit of self-confidence and never plays the victim.

In many ways, Phoebe's a typical cat (if there is such a thing). She often gallops through the house at midnight for no apparent reason, sneaks under

Phoebe claiming her rightful spot

the kitchen table at breakfast time to bite everyone's toes, and seems to anticipate my work schedule, falling asleep on my computer keyboard just before I sit down at my desk to write. She can spend half an hour exploring the inside of a paper bag, and she insists that her dish is empty when really she's just eaten the food in the very center of it.

She also enjoys being an enigma: Catnip bores her and so does her bed—she prefers sleeping against a rock painted to look like a cat. The toe spacer thingy from my pedicure offers an hour's worth of entertainment, while the overpriced cat toy covered with feathers that squeaks like a mouse is met with disinterest if not downright disdain.

Considering that most of her time is spent napping and hiding from us, Phoebe still has a significant impact on our lives. Wherever she's stretched out with her eyes closed, whether it's in front of the woodstove (her favorite spot) or in the dent she's made along the back of the couch (second favorite), she infuses the room with tranquility. Her mere presence is soothing. And now that the kids have all grown up and moved on, she gives the house life—and gives the kids a reason to come back and visit.

She fully embraces her importance in our world. She knows she's needed. She knows she's adored. Hopefully she'll be in our lives for another twelve years.

Cindy Copeland

1

Be the exception

Confident and daring—with just a spark of madness—cats are the ultimate nonconformists. These mischievous misfits do as they please, wholly unconcerned with the opinions of others. They deliberately choose the peculiar over the predictable, pushing boundaries and making up the rules as they go along. A cat would much rather fail with an outlandish idea than succeed with a conventional one.

Maybe cats sense that progress is achieved only when familiar patterns are broken by those who dare to try something new. Or maybe they instinctively know that harmony is the result of everyone singing a different note. Or perhaps it's a lot simpler than that: Cats have figured out that it's just more fun to be weird than it is to be ordinary.

See things *differently*.

Don't be a copycat.

Stay a little *wild.*

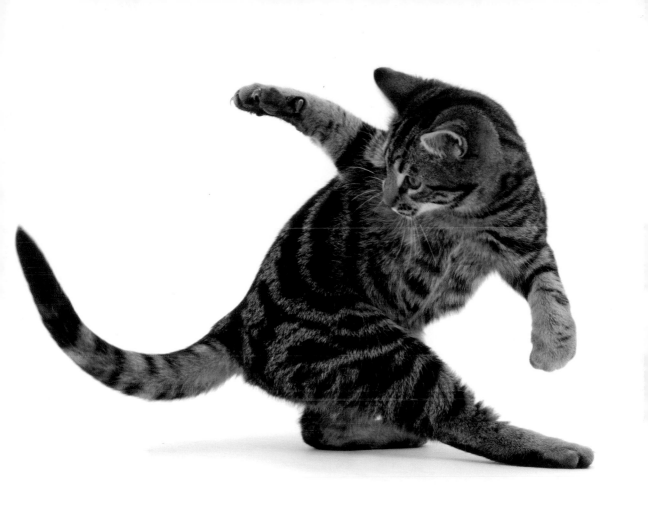

Stay a little *weird*.

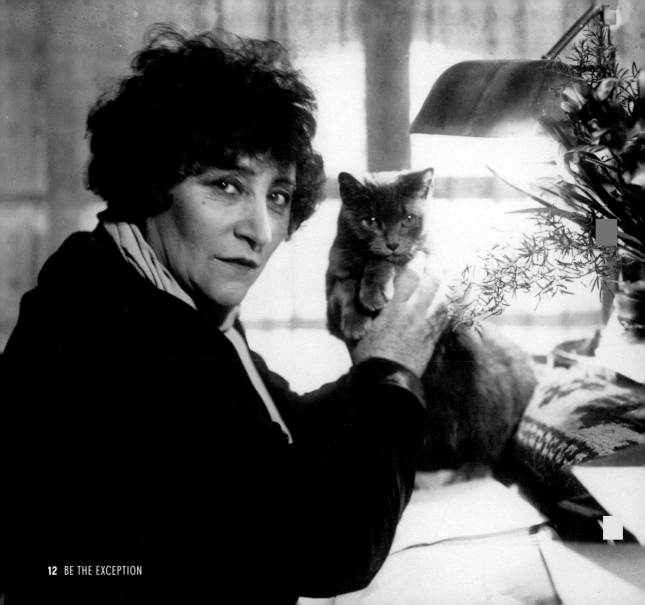

"There are no ordinary cats."

—COLETTE

Because of her lifelong affection for cats, the French novelist Colette has been called the Original Cat Woman. Perhaps best known for the novella *Gigi*, which was adapted for stage and screen, Colette also wrote a novel called *La Chatte* (*The Cat*), published in 1933. At the end of her life, confined to her apartment overlooking Paris, the acclaimed author took great comfort in the company of her beloved cats. "Time spent with a cat," Colette once said, "is never wasted."

Don't feel obligated
to explain yourself.

You'll be remembered for what sets you apart.

What's the point of doing something the way it's always been done?

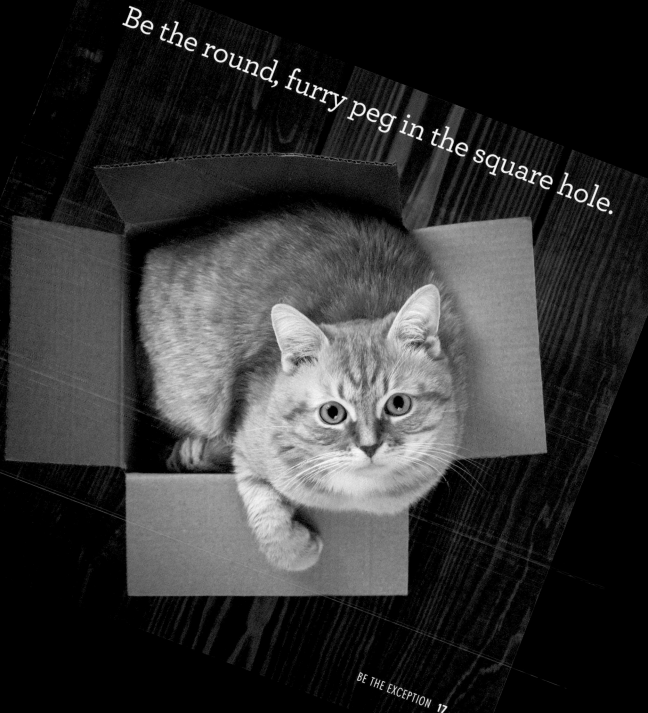

Be the round, furry peg in the square hole.

Follow your heart.

When Tatyana Antropova, the director of the zoo in the Siberian city of Tyumen, realized that a newborn squirrel monkey named Fyodor had been abandoned by his mother, she took him home to care for him. To her astonishment, her sixteen-year-old cat, Rosinka, adopted the monkey, comforting him and letting him cling to her back the way mother squirrel monkeys do. Fyodor left Rosinka's side only when he needed to eat. Despite the fact that the monkey was "naughty," according to the zoo director, and was biting and pinching the elderly cat, Rosinka was patient and kind, tending to him until he was old enough to rejoin the other squirrel monkeys at the zoo.

Rosinka and Fyodor, fast friends

IT DOESN'T MATTER
WHETHER OR NOT
THE WORLD IS READY
FOR YOU.

SHOW UP ANYWAY.

"In order to be irreplaceable one must always be different."

—COCO CHANEL

> "If I'm going to sing like someone else *then I don't need to sing at all.*"
>
> —BILLIE HOLIDAY

Are You a Nonconformist?

Many cat owners proudly identify with their feline companions when it comes to being unconventional. You are a nonconformist if you . . .

. . . surround yourself with people whose opinions and life experiences differ from your own.

. . . regard failures as opportunities rather than dead ends.

. . . often ask questions that start with "why" or "what if."

. . . feel unaffected by peer pressure.

. . . avoid using words that sidestep critical analysis, like "love" or "hate."

. . . frequently seek out information that challenges what you believe.

. . . use rules as guidelines but refuse to be limited by them.

DON'T APOLOGIZE *for being a* **TROUBLEMAKER.**

THERE'S NO SUCH THING AS A

TYPICAL CATNAP.

Shed.

Shred.

Make unconventional choices.

"Shoot for the moon. Even if you miss, you'll land among the stars." —LES BROWN

On October 18, 1963, a cat named Félicette was put in a capsule atop a French rocket and blasted into space from a launch pad in the Sahara desert. The black-and-white stray was chosen from among fourteen cats that had undergone extensive training in preparation for the flight. Her calm demeanor and small size made her the perfect astronaut—or astrocat, as she was dubbed by the press. During the fifteen-minute flight, electrodes implanted in her brain sent neurological impulses back to French scientists, providing valuable information. After traveling one hundred miles into space, the capsule separated from the rocket and Félicette parachuted safely back to Earth.

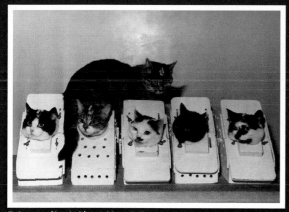
Félicette (far left) and her fellow trainees

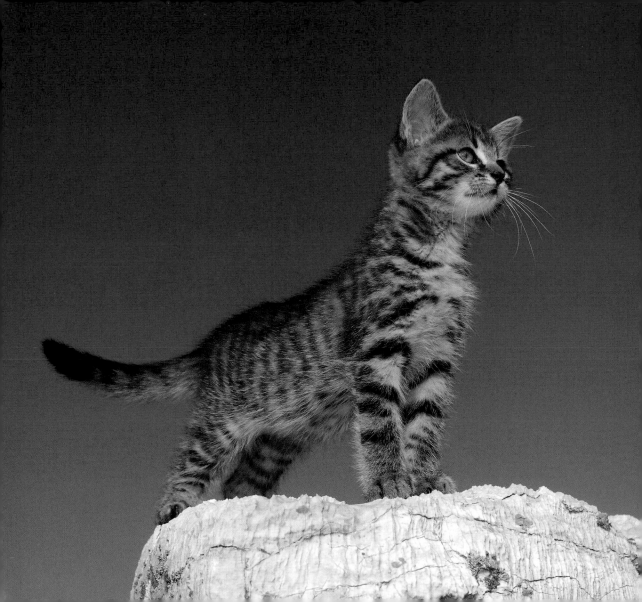

2

Take it all in

Cats are often misunderstood, labeled standoffish and aloof when they're simply observing from the sidelines. They learn by studying the world around them, attentive to every detail, alert to the slightest change. Independent and mysterious, they slip away unnoticed when they crave solitude—only to materialize hours later at the sound of a can opening or the rustling of newspaper pages.

Cats remind us how important it is to cultivate solitary pursuits, and they teach us that being alone doesn't have to mean being lonely. They show us that carving out time every day for quiet reflection is not only acceptable but necessary for spiritual renewal. And when they're in our company, they teach us that a comfortable, affectionate silence can be just as satisfying as the most spirited discussion.

DRAW STRENGTH
from SOLITUDE.

Talk less, listen more.

Find your own square of sunshine.

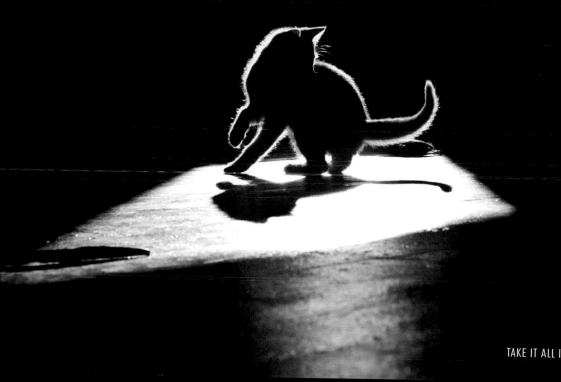

Now and then, let people miss you.

Let them wonder where you've been for the last few hours.

A cat's whiskers act like kitty radar,
helping him determine whether or not
he will be able to fit through a tight space.

"...BE ALONE, THAT IS WHEN IDEAS ARE BORN."

—*Nikola Tesla*

How great minds found the solitude they needed for inspiration

Prolific composer **Wolfgang Amadeus Mozart** found alone time while "traveling in a carriage, or walking after a good meal, or during the night when I cannot sleep."

Theoretical physicist **Albert Einstein** made time for long walks on the beach. During the workday sometimes he would "lie down . . . and gaze at the ceiling while I listen and visualize what goes on in my imagination."

For **Franz Kafka**, influential novelist and short story writer, staying put was the answer: "You need not leave your room . . . just learn to become quiet, and still. . . ."

Go your **own** way.

SILENCE is not the same as *indifference.*

Watch and wait.

The world will present
itself to you.

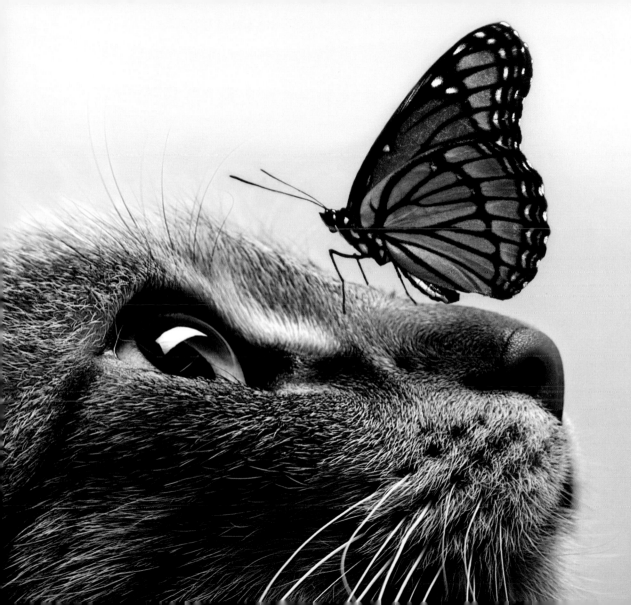

Maintain an air of *mystery.*

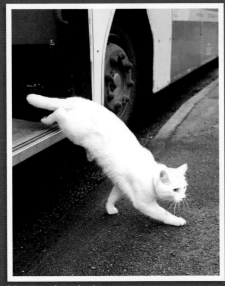

Macavity disembarks.

Two or three mornings each week, a white cat with one blue eye and one green eye waits at a bus stop in the West Midlands, England. When the Walsall to Wolverhampton bus pulls up, he hops on and takes a seat, disembarking at the next stop near a fish and chips store. He only travels one way, and no one is quite sure how he gets back home. A fellow passenger praises the cat as the "perfect passenger," explaining that "he sits quietly, minds his own business, and then gets off." Bus drivers and passengers have nicknamed him Macavity after the mysterious cat in T.S. Eliot's *Old Possum's Book of Practical Cats.*

"Books. Cats.
Life is good."

—EDWARD GOREY

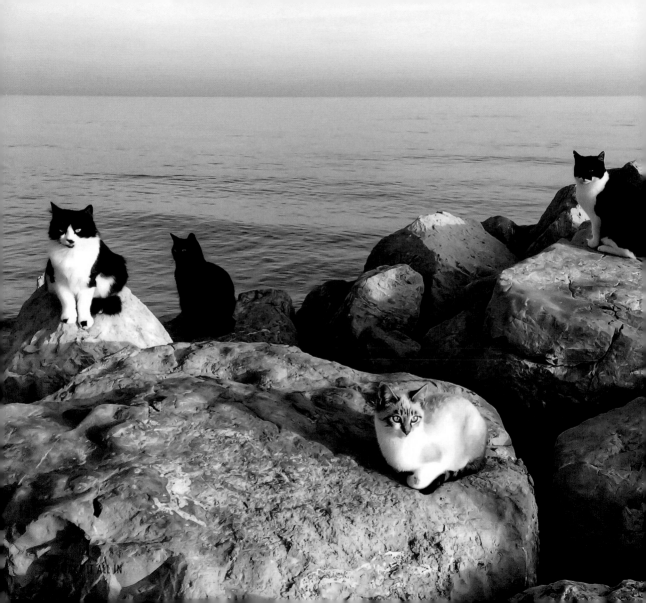

Learn to be alone together.

SOMETIMES
IT'S BEST
to let the cat
stay in the bag.

"If cats could talk, they wouldn't."

—Nan Porter

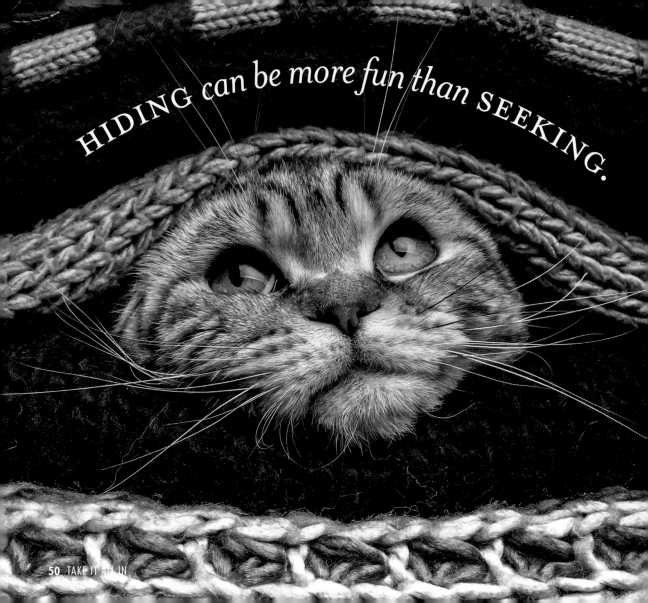

HIDING can be more fun than SEEKING.

Sometimes two is a crowd.

Soak up solitude when the rest of the world is sleeping.

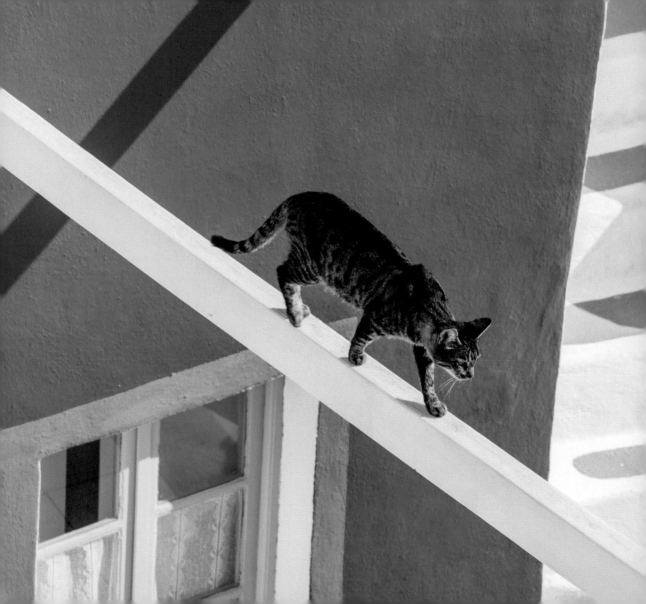

3

Live on *the edge*

Deep within even the most spoiled house cat resides a feral and fearless wildcat. Despite being creatures of habit with an affinity for comfort, cats crave freedom and adventure. They're true explorers, setting out alone day after day with no fixed destination, driven by curiosity and an innate desire to discover something new.

Always on the prowl, ready to pounce, cats take remarkable risks to defend their turf or a beloved friend—or simply for a thrill. That their behavior frequently defies explanation is part of their mystery and allure. We will never really know the breadth of their adventures, or how fully they live each one of their allotted nine lives.

Be FEARLESS—
but have an escape plan.

Don't hesitate to

SHOW YOUR CLAWS.

> # "IT IS NOT THE MOUNTAIN WE CONQUER BUT *ourselves.*"
>
> **—Edmund Hillary**

When avid climber Craig Armstrong adopted Millie, an abandoned kitten, from a Utah shelter, he never imagined that she would become his enthusiastic and fearless climbing partner. But he felt guilty leaving her home alone while he was climbing, so he decided to see if he could train her to accompany him. It wasn't long before he realized that she had a real affinity for the sport. With no fear of heights, remarkable balance, and a willingness to take risks, Millie often leads the way on their ascents. Wearing a harness for safety, she has scaled some of Utah's most famous climbing landmarks, even descending Alcatraz Canyon, which few people have been able to do. Craig says he enjoys his expeditions with Millie not only because she cuddles with him at night in his sleeping bag, but because the pace when they're together is more relaxed, and he's able to see the world in a new way, through her eyes.

Millie explores a slot canyon. ▶

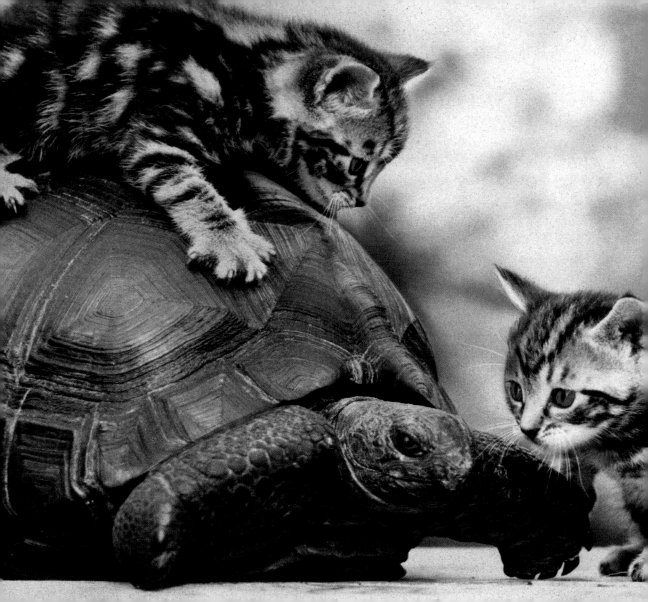

"I may be going nowhere,
but what a ride."

—SHAUN HICK

Sometimes the best adventures are the ones you never planned on taking.

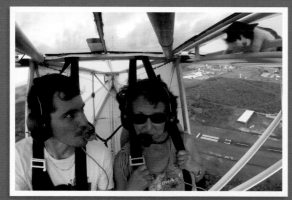

The pilot spots his stowaway.

At an aviation training school in Kourou, French Guiana, pilot Romain Jantot didn't notice that a cat had stowed away on the wing of his open-cockpit glider until he and his human passenger were thousands of feet in the air! Thankfully, they all landed safely. The cat was seemingly unfazed and continues her frequent visits to the school: "She is still our mascot," Jantot said.

"Always make a total effort, even when the odds are against you."—ARNOLD PALMER

Invite
yourself
along.

5 Tips for Road Tripping With Your Cat

Most cats prefer their familiar routine and environment to life on the road, but if you want to take your kitty on a car trip, here are some suggestions.

1 Get your cat accustomed to the travel crate ahead of time: Let him explore it at home with familiar bedding inside. Just before the trip, spray the crate with a soothing product like Feliway.

2 To desensitize your cat to motion sickness, start with shorter outings and gradually work up to longer car trips (and never feed him just before you leave).

3 Load up on the supplies you'll need (a leash, disposable litter boxes, and bottles filled with familiar water from home), and plan frequent pit stops so that your cat can drink and use the litter box.

4 Be sensitive to your cat: Keep the car at a consistent, comfortable temperature; turn down the volume on the radio; and don't leave him alone for more than a few minutes at a time.

5 Make sure your cat wears an ID tag, securely fastened to his collar.

"A good traveler has no fixed plans, and is not intent on arriving."

—Lao Tzu

TAKE
CHANCES.
Act as if you have
eight more lives.

Be ready to **pounce.**

LISTEN TO YOUR INNER LION.

When a black bear wandered onto Jack's property in West Milford, New Jersey, the (clawless) tabby cat was not pleased. Hissing and yowling, he confronted the bear, then he chased it up a neighbor's tree. After about fifteen minutes, the bear tried to flee, but Jack responded even more ferociously, sending him scrambling up a second tree. Eventually, Jack's owner, Donna Dickey, called the cat into the house to give the bear a chance to escape into the woods. She shrugged off Jack's behavior: "He doesn't want anybody in his yard," she explained. Clearly.

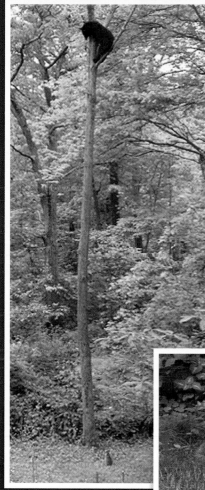

Jack trees a bear.

Sometimes you have to leap BEFORE you look.

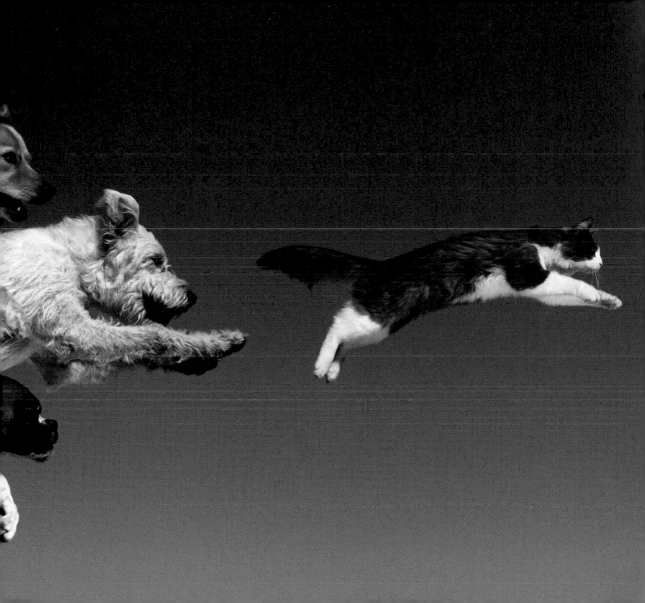

"You have enemies? Good. That means you've stood up for something, sometime in your life."

—WINSTON CHURCHILL

British Prime Minister Winston Churchill was immensely fond of cats, and he owned many throughout his lifetime, including Margate, Tango, and Mickey. He named one of his favorite cats Nelson, after a famous British admiral. He admired Nelson's courage, bragging that he was "the bravest cat I ever knew. I once saw him chase a huge dog. . . ." Churchill's cat Jock was regarded by household staff as a troublemaker, but that didn't prevent Churchill from including him in his eighty-eighth birthday celebration, sleeping with him most nights, and waiting for Jock's arrival before he ate his meals. When Churchill died, Jock was by his side.

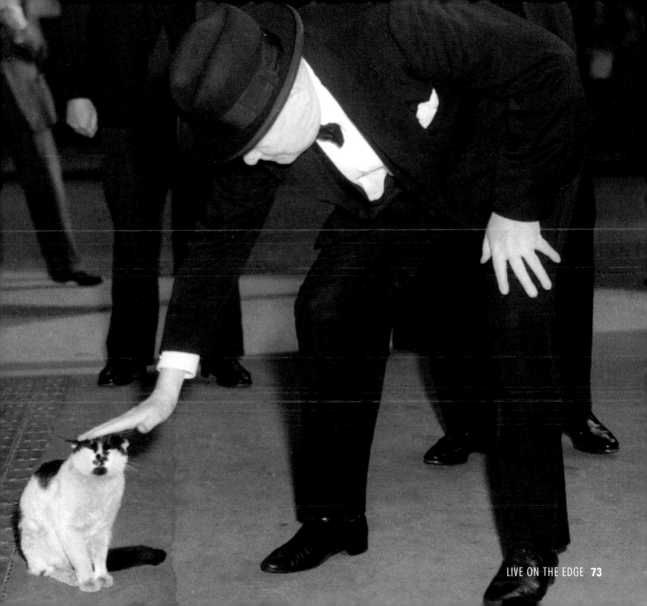

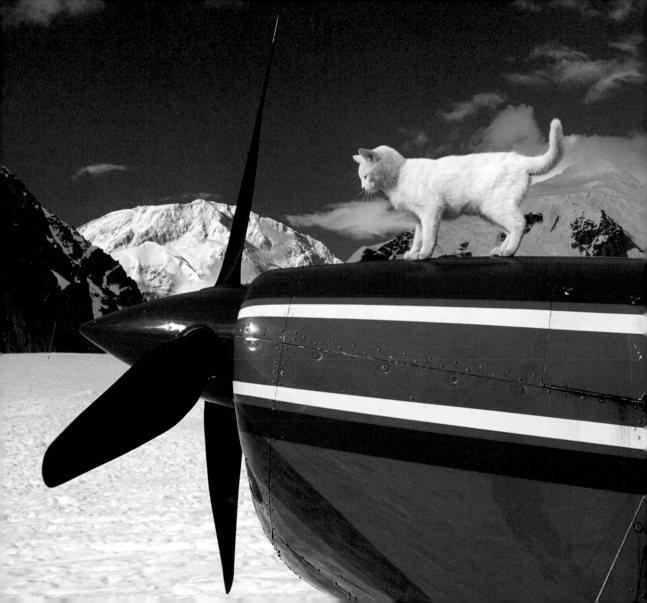

Always be on the lookout for your next big adventure.

4

Let your mind wonder

Cats are highly intelligent, but they don't care whether or not anyone knows it. They aren't learning new things to impress others; after all, a cat is a solitary animal with no pack to please.

Repeating pointless tricks on command will never be of much interest to a cat. Being intuitive, resourceful, and adaptable, however, are extremely useful feline traits. The curiosity of cats is legendary, and their cleverness and persistence have led to countless starring roles in viral videos enjoyed by millions.

A cat's unique kind of intelligence is not easily measured. (Is it surprising that cats aren't the most cooperative research subjects?) But consider this: Cats have us trained to feed them when they want to be fed and provide them with shelter, entertainment, and affection, with no guarantee of even a pleased purr in return. By any definition, that's smart.

It's not how smart you are, it's *how* you are smart.

Your cat is smarter than your iPad—a lot smarter!
An iPad can process an astounding 170 million
operations per second, but your cat's brain can
handle 6.1 trillion. As for storage space? Your cat
wins again: 91,000 gigabytes to an iPad's 60.

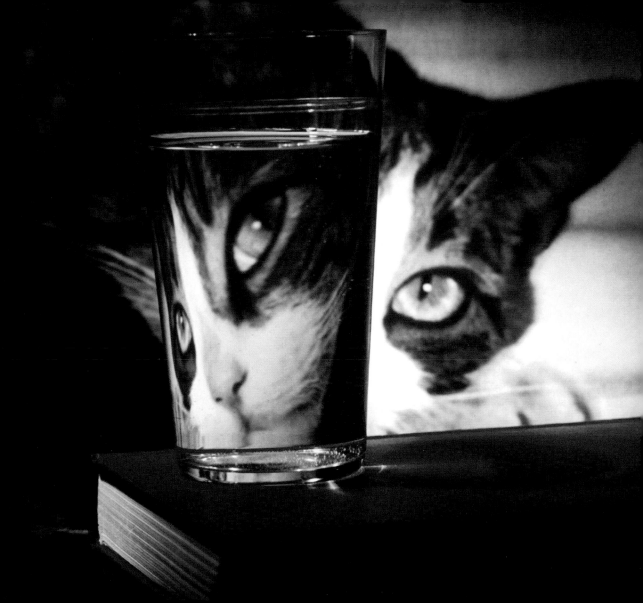

Be curious.
Have more questions than answers.

Have a thinking spot.

SOMETIMES SILENCE *is the* BEST ANSWER.

LEARN TO MAKE SENSE
OF THE DARKNESS.

Because cats are most active at dawn and dusk, their night vision is far superior to ours. The shape of their eyes as well as the number of rod cells (six to eight times more than humans have) allow them to see well in low light and also to sense movement in the dark.

Show off your street smarts.

Holly trekked 200 miles home.

No one has any idea how she did it, but two months after slipping away from her owners while on an RV camping trip in Daytona Beach, Florida, Holly, a four-year-old tortoiseshell cat, walked 200 miles back to her house in West Palm Beach. It was New Year's Eve when a weak and emaciated Holly staggered into a backyard a mile from where she had lived with her owners, Jacob and Bonnie Richter. As remarkable as her story is, Holly is not the only cat to have accomplished such a feat. Even more amazing is the tale of Howie, an indoor Persian cat from Australia, who in 1978 traveled 1,000 miles back home after being left with relatives while his family was on vacation.

Don't let anyone call you *picky*.
You are *selective*.

Know when it's good to blend in . . .

. . . and when it's better to stand up and stand out.

"Adopt the
pace of nature:
her secret
is PATIENCE."

—RALPH WALDO EMERSON

"I have learned a great deal from listening carefully."

—ERNEST HEMINGWAY

Acclaimed American novelist Ernest Hemingway admired cats for their "absolute emotional honesty." While people may hide their feelings, "a cat," he declared, "does not." He shared his home in Key West, Florida, with more than thirty cats, one of which was a polydactyl (six-toed) cat named Snow White, given to him by a ship's captain. Dozens of descendants of Snow White still live on the property today, also sporting six toes!

The most meaningful thing you can give someone else is your full attention.

Change your point of view.

"Nobody knows I'm there, yet I know everything."

—Anna Paszkiewicz

"In any library in the world, I am at home, unselfconscious, still and absorbed."

—Germaine Greer

Dewey lived in the library for nineteen years.

Library cats entertain patrons, promote literacy and pet adoption, and, of course, keep the mice at bay. Perhaps the most famous library cat of all was Dewey Readmore Books, discovered nearly frozen to death in the night drop box of the Spencer Public Library in January of 1988. The new librarian, Vicki Myron, nursed the tiny kitten back to health, and Dewey repaid her kindness by raising the spirits of everyone in the struggling Iowa farm town. Dewey eventually became so popular that he attracted visitors and fan mail from all over the world. When he died, more than 250 publications carried his obituary. Not long after that, Vicki retired from her job at the library and wrote a book about his life, which became a *New York Times* bestseller.

It's good to go after what you want, but sometimes it's better to wait and see if it will come to you.

5

Add whimsy to the world

Cats like to amuse themselves in peculiar ways, and in doing so, they also amuse the rest of us. A cat may squeeze itself into a teeny tiny basket, or twist into the shape of a pretzel and fall sound asleep, or stampede through the house chasing imaginary prey. Cats are as famous for their antics as they are for their expressions of bored indifference as they stare back from atop someone's head or from the inside of a winter boot.

When they're being silly and playful, cats remind us not to take ourselves too seriously. They encourage us to make time for nonsense, no matter how old we are: After all, adult cats are as kooky as kittens! And above everything else, they teach us that the best reason to do anything is because it's just plain fun.

Act like you can see things
the others can't.

JUST FOR FUN.

Find your *perfect* playmate.

Know
how to get
a laugh.

"One cat just leads to another."

—ERNEST HEMINGWAY

Cats outnumber people on Aoshima Island, one of about a dozen "cat islands" in Japan. In Japanese culture, cats are considered good luck charms, said to bring money and good fortune to all who cross their paths. Aoshima cats survive on food given to them by locals and tourists.

SHOW OFF
FOR YOUR FRIENDS.

Create awkward moments.

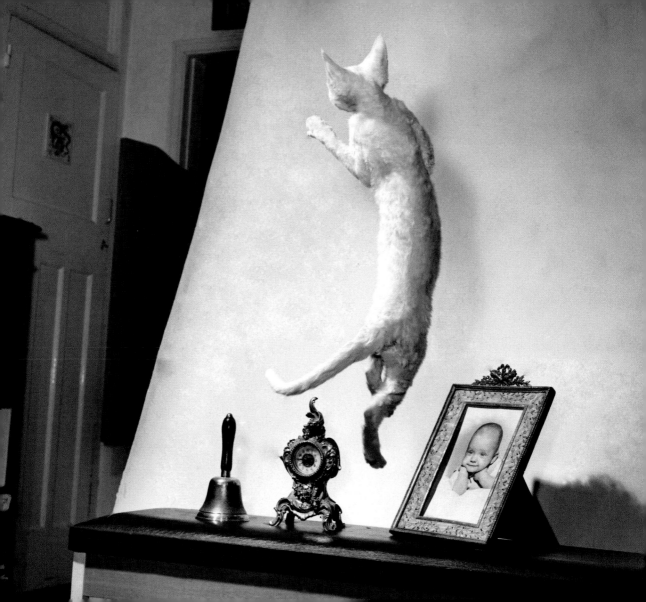

"Be the weird you want to see in the world."

—Wein Benlick

Look what the cat dragged in.

Norris inspecting his loot

Norris, a real-life cat burglar, slinks through his Bristol, England, neighborhood at night, stealing from clotheslines and even sneaking into houses. He initially favored dishcloths and rags, but recently he's been drawn to more personal items like bras and panties. Upon returning home, he drags his loot through the cat door and then meows until his owners, Richard and Sophie Windsor, wake up and acknowledge his haul. The Windsors have sent letters to the neighbors explaining their cat's embarrassing habit, and make regular visits to return the items he steals. "Fortunately," Richard said, "our neighbors have been good-natured."

Perfect a look of amused indifference.

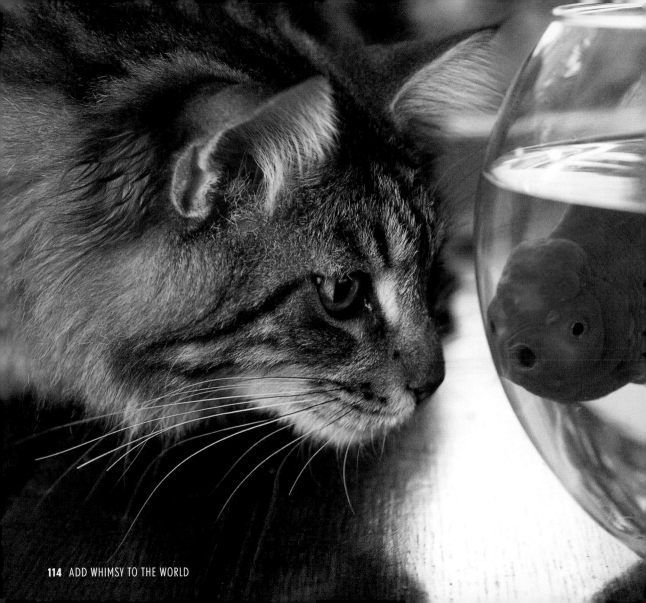

"Cats do not have to be shown how to have a good time. . . ."

—JAMES MASON

Cats are very good at entertaining themselves, but it can be fun to lend a helping hand:

- Leave out paper grocery bags and empty boxes of various sizes for exploring.

- Set up a bird feeder near a window so that your cat can watch the action from indoors.

- Place an aquarium—or a battery operated toy aquarium— where your cat can enjoy the show.

- Plant wheatgrass, rye, catnip, oat, and barley in a tray and set it near a window for indoor frolicking.

- Fold down one end of a toilet paper tube, put a treat inside, and then fold the other end so that your cat has to work a bit to get at the treat.

- Throw a towel or sheet over the coffee table to make a cat fort.

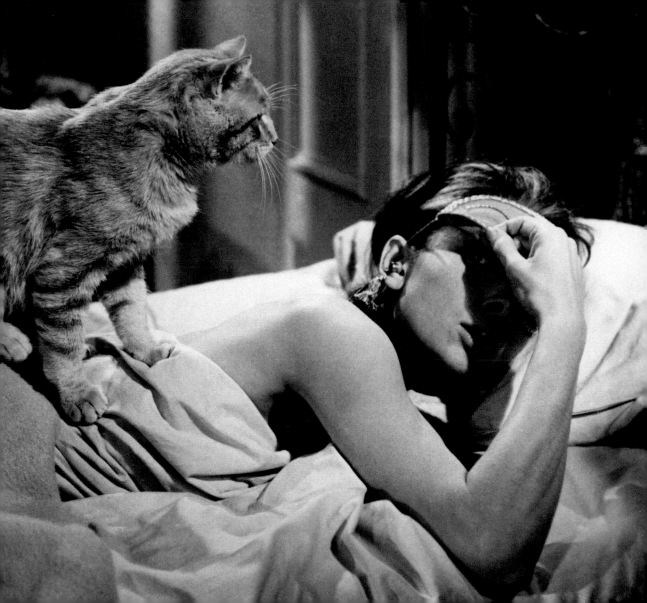

There's a fine line between *adorable* and ANNOYING.

In *Breakfast at Tiffany's*, Audrey Hepburn's character, Holly Golightly, refers to her cat simply as "Cat." The feline star was actually named Orangey, and he appeared in a number of films, winning two Patsy awards (the animal equivalent of an Oscar) during the course of his illustrious acting career.

"There's power in looking **SILLY** and not caring that you do."

—*Amy Poehler*

"IN POLITICS, ABSURDITY IS NOT A HANDICAP."

—Napoleon Bonaparte

Stubbs, mayor of Talkeetna

Since 1997, a cat named Stubbs has been the honorary mayor of Talkeetna, Alaska, population 876. She has an office of sorts in Nagley's General Store and is the town's major tourist attraction, greeting thirty to forty visitors a day and receiving fan mail from around the world. The store manager, Lauri Stec, found Stubbs in a box that had been left in the parking lot and came up with the name because the kitten didn't have a tail. Since taking office, Stubbs has leapt out of a moving truck, fallen into a restaurant fryer, and been mauled by a dog, but each time she's recovered and returned to the store to continue performing her mayoral duties.

REMEMBER: You can purr your way out of *just about anything*.

Go ahead, try it!

You know you'll land on your feet.

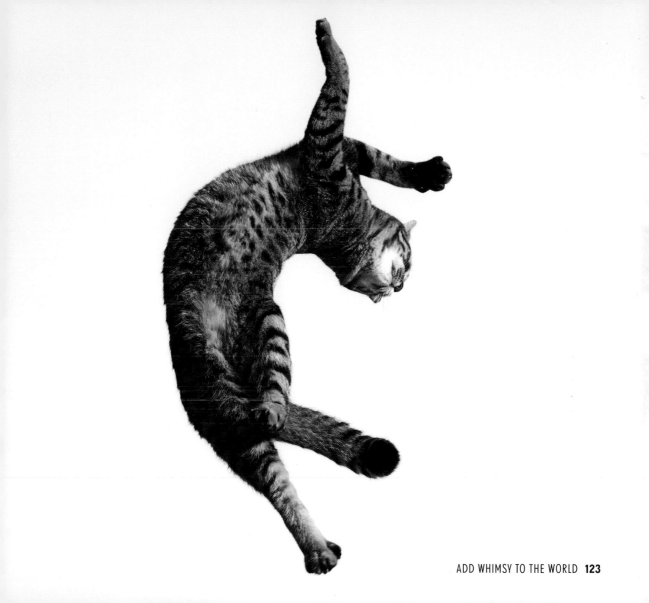

Never let sleeping dogs lie.

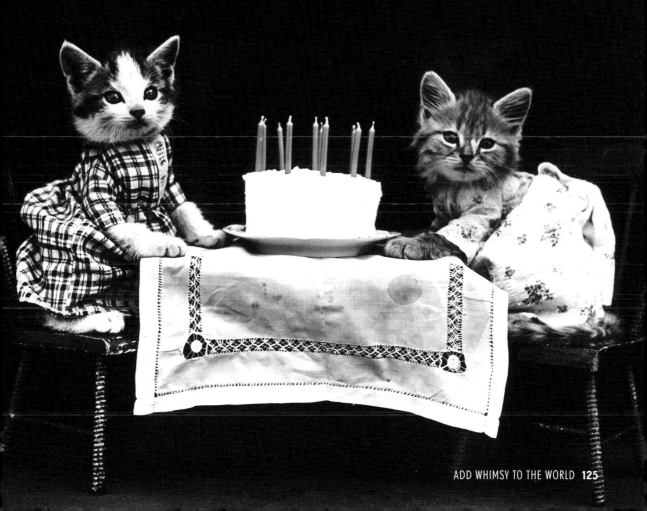

Humor people.

Make a
mad dash!

Cats love to chase . . .

• a hand moving under a blanket • a ping pong ball • a crumpled ball of paper or tinfoil • rings cut from a toilet paper tube • catnip-flavored bubbles • handles of a shopping bag, cut and tied in the middle to make a "spider" • a piece of string tied to someone's ankle

"Never try to outstubborn a cat."

—Robert A. Heinlein

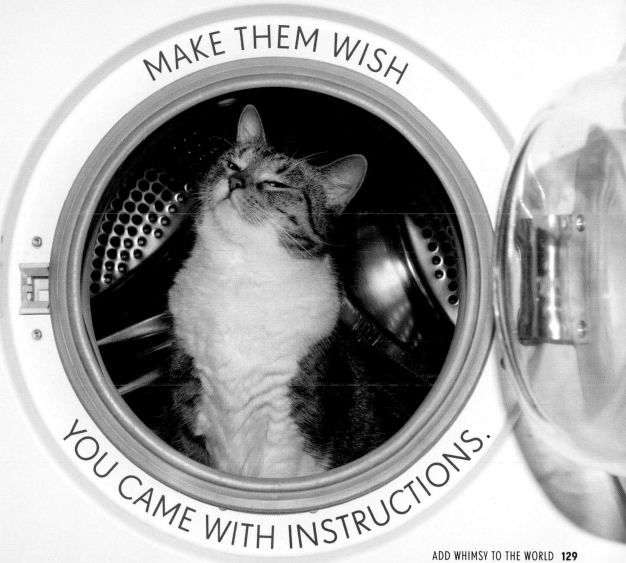

MAKE THEM WISH
YOU CAME WITH INSTRUCTIONS.

"Life is short, break the rules . . . and never regret anything that made you smile."

—MARK TWAIN

Beloved American writer and humorist Mark Twain shared his farm in central Connecticut with eleven cats, admitting that "I simply can't resist a cat, particularly a purring one." Twain once suggested that "if man could be crossed with the cat it would improve man, but it would deteriorate the cat."

6

Rub people the right way

A cat's adoration is quiet and nuanced. By rubbing up against us or maintaining eye contact, by bunting or kneading, a cat shows her devotion. Cat lovers appreciate these gestures all the more because we understand that a cat is not a social creature by nature, so a relationship with her human family runs counter to her solitary instincts.

A cat's mere presence brings a sense of peaceful well-being to those close by. Whether a bona fide therapy animal or just a contented, sleeping pet, a cat is a true comfort and can make any place feel like home.

"Too often we underestimate . . . a smile, a kind word, a listening ear, an honest compliment, or the smallest act of caring, all of which have the potential to turn a life around."

—Leo Buscaglia

RECOGNIZE THE POWER OF YOUR PURR.

There's always room for

one more at the table.

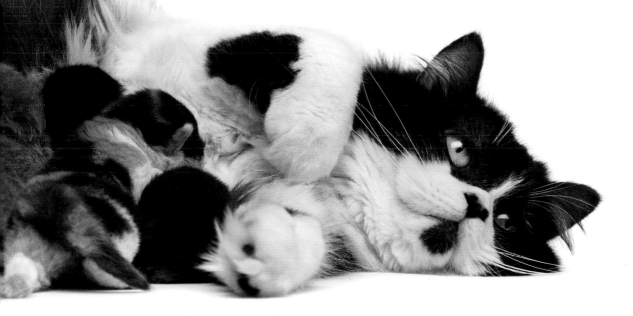

"A cat does not want all the world to love her. Only those she has *chosen to love.*"

—HELEN THOMSON

Take the high road.

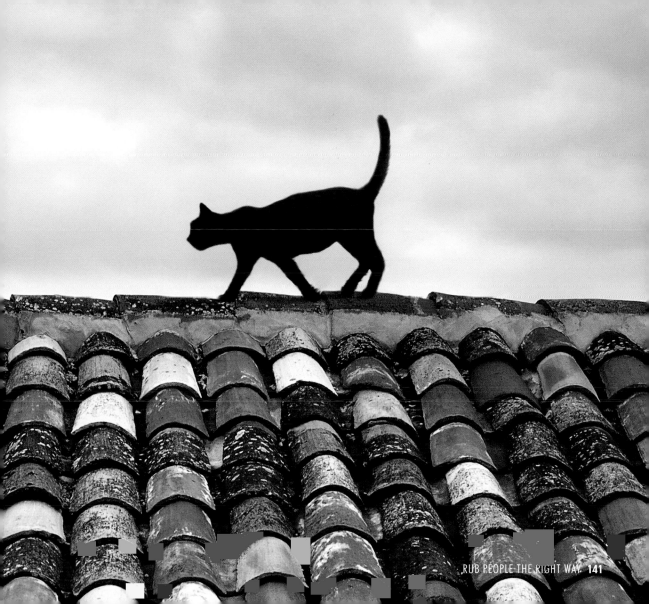

Put your family first.

Scarlett with her adoptive mom

Scarlett was tending to her five kittens in an abandoned garage in Brooklyn, New York, in 1996 when the building suddenly went up in flames. When firefighters arrived, they saw the calico cat running in and out of the burning building, rescuing her kittens one by one. Despite the fact that she was blinded by the fire and badly burned, she continued going back until she had retrieved all five. After Scarlett was taken to an animal shelter along with the four surviving kittens, her story drew international attention. The kittens were adopted in pairs, and Scarlett was adopted by Brooklyn resident Karen Weller. In her house, Karen said, "it was all about Scarlett." Scarlett may have been homeless at one time, but with Karen, she was the "top cat."

Be a peaceful presence.

Cats sleep about sixteen hours a day. They prefer "cat naps," but when they do sleep deeply, their brain wave patterns are similar to the ones we produce when we're dreaming.

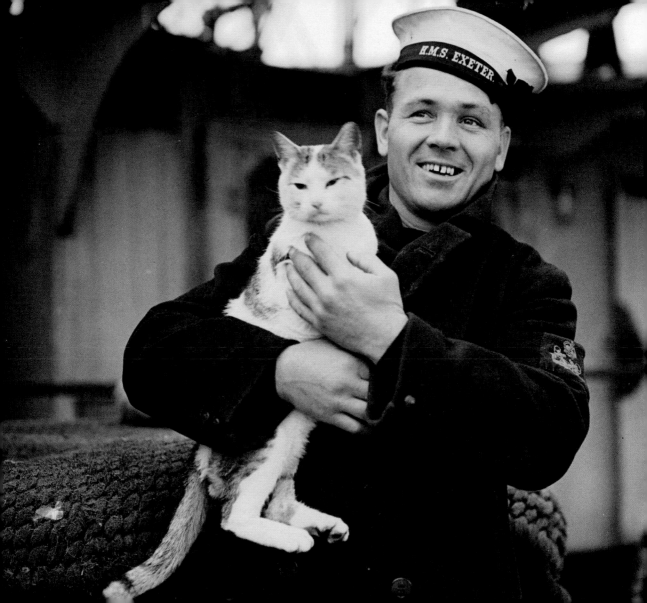

"Do your little bit of good where you are; it's those little bits of good put together that overwhelm the world."

—Desmond Tutu

Research shows that cats appear to remember when people are kind to them, and return their affection at a later time.

SHARE YOUR SECRET PLACE.

Act like this is the moment you'll be known for.

Masha saved a baby boy's life.

One frigid winter night in 2015, an infant was abandoned on the steps of an apartment building in Obninsk, Russia. A stray cat (nicknamed Masha by area residents) discovered the crying baby boy inside a cardboard box and jumped in. The next morning, a concerned neighbor responded to Masha's meows and was shocked to discover the cat curled up beside the baby, keeping him warm. She called for help, and as the baby was carried into an ambulance, Masha followed closely. After the ambulance pulled away, Masha waited in the road for several hours, seemingly hopeful that someone would bring the baby back. The infant, who'd been left with extra clothing, diapers, and baby food, survived and was reported to be in good health, thanks in large part to the kindhearted cat.

"Carry each other's burdens." —GALATIANS 6:2

What makes a good therapy cat?

Because cats have such a positive impact on people's mental and physical health, many become trained as therapy animals, bringing comfort to those in hospitals, schools, nursing homes, and even prisons. To be considered for one of the many programs that certify pet therapy teams, your cat should be:

- Friendly and calm.
- Current with all vaccinations, and have trimmed claws.
- At least a year old, and have lived with you for most of that time.
- Comfortable wearing a harness.
- On a diet that is not a raw protein diet (which can make people more susceptible to infections).
- At ease in new and unpredictable situations.

"The world is changed by your example, not by your opinion."

—Paul Coelho

Despite our preconceived notions, cats and dogs can indeed live in harmony! If possible, allow a kitten and a puppy to grow up in the same household. When bringing together older animals, look for cats and dogs that are curious about one another but are not fearful or aggressive. Avoid feral cats and dogs that are bred to hunt and herd. Introduce them to one another gradually and with supervision.

Be a blessing.

Oscar has a sixth sense.

Pets have always been welcome at the Steere House Nursing & Rehabilitation Center in Rhode Island; the staff is well aware of the therapeutic benefits of living with animals. One of its resident pets, however, is exceptional. Oscar the cat has the uncanny ability to sense when a patient is nearing death and to offer his special brand of comfort. In fact, his gift was explored in a 2007 article in the *New England Journal of Medicine*. The baffled medical staff has documented about one hundred cases where Oscar indicated residents were close to death. The author of the journal article, Dr. David Dosa, speculated that the cat may be responding to "a pheromone or a scent" present in the patient. No matter how he does it, Oscar's ability to determine impending death is so accurate that doctors and nurses now notify family members when the cat appears at a patient's bedside, giving them time to get to the nursing home to say good-bye. For elderly patients without families, who would otherwise die alone, Oscar provides a source of comfort and companionship in their final hours.

You're never too small to make a big difference.

7

Make an entrance

Cats hold themselves in high regard—and that's admirable. Healthy self-esteem doesn't mean feeling superior to others, it means feeling personally content. After all, cats would never waste time comparing themselves to other cats (or fretting about what other cats—or humans—think about them).

Cats believe they deserve our attention and praise, and they expect to be treated well. They aren't shy about letting us know what they want. And though they will return our affection, cats know just when to stop, leaving us eager for more.

Wait for them to **WOW** you.

"Think like
a queen."
—Oprah Winfrey

Stop traffic.

Confidence makes you *sexy.*

Take care of yourself.

3 Good Reasons to Put Yourself First

Healthy selfishness does not mean being inconsiderate. Rather, it means you're aware that you need to meet your own emotional and physical needs in order to be your best self. You are self-focused, not self-absorbed. Here's why you should start putting yourself first:

1. **You can't pour from an empty cup.** Carving out time to take care of yourself—whether that means joining a gym, getting a great night's sleep, buying and preparing healthy food, or taking relaxing vacations—means that you'll have the personal resources to take care of others when they need you.

2. **Your relationships will be in balance.** People who subscribe to healthy selfishness don't expect other people to read their minds and make them happy—they know how to fulfill their own needs. It's hard to be in a relationship with a martyr; an equal partnership is much more rewarding.

3. **You'll lift up those around you.** By stepping back sometimes and allowing those closest to you to solve their own problems and make mistakes (and learn from those mistakes), you are empowering them and helping them develop necessary skills.

An alley cat is as proud
as a Persian.

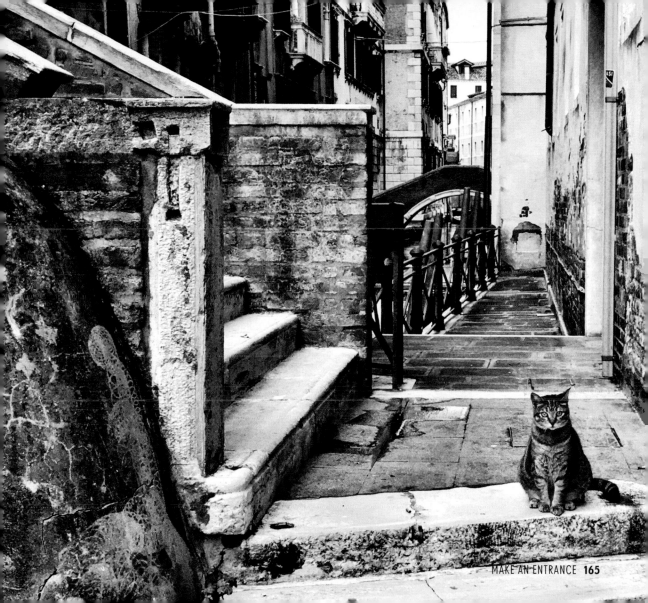

Look them *straight in the eye.*

Let them
know how
you really
feel.

PRETEND THAT'S WHAT YOU MEANT TO DO.

Insist on a seat
at the table.

People Foods You Can Share with Your Cat

We all feed our kitties from the table now and then. But some foods are better for them than others. Here are some human foods that we can safely share with our feline friends (in small quantities, of course, and without any seasonings).

- **Scrambled or hard-boiled eggs** • **Cooked chicken, turkey, fish, or lean ground beef** • **Green beans** • **Bananas** • **Melon** • **Peas** • **Apples (skinless)** • **Canned pumpkin** • **Blueberries**

Though black cats are considered to be bad luck in the United States, they are regarded as good luck charms in the United Kingdom and Australia.

"Never love anybody who treats you like you're ordinary."

—Oscar Wilde

Don't let **anybody** close the door on you.

Leave them
wanting MORE.

Photography Credits

Title Page: © Shaina Fishman; **Table of Contents:** Sergii Figurnyi/fotolia.

500PX: fstop_images p. 28, Akimasa Harada p. 123, SébastienLoval p. 96, Mārtiņš Lūsis p. 64, Priscila de Lyra p. 174, Seji Mamiya p. 67, Dorien Soyez p. 43, Vladimir Zotov p. 34; **Alamy:** Juniors Bildarchiv GmbH p. 24, Image Source p. 129, Evgeny Shmulev p. 84; **Associated Press:** p. 18, Stew Milne p. 152; **Craig Armstrong:** p. 59; **guremike:** p. 14; © **fotolia:** bubblegirlphoto p. 168, Sergii Figurnyi p. 57, Glenda Powers p. 169; **Getty Images:** Lori Adamski-Peek/Photographer's Choice p. 49, Aifos p. 149, Barcroft Media pp. 15, 19, Stephen Beifuss/EyeEm pp. 46–47, Marcel ter Bekke p. 139, Bert Hardy Advertising Archive/Hulton Archive p. 79, Bettmann p. 23, Charlotte Björnström/EyeEm p. 66, Michael Blann/DigitalVision p. 175, blink p. 21, Bobiko/Moment p. 48, Retales Botijero p. 118, Jane Burton/Nature Picture Library p. 9, Claudia Cadoni/Moment Open pp. 32–33, Ryerson Clark/E+ p. 35, Paolo Cossich/EyeEm p. 165, Daily Herald Archive/SSPL p. 144, Dashabelozerova p. 102, Tim Davis/Corbis/VCG pp. 70–71, di4kadi4kova/Moment p. 153, druvo p. 151, Nat Farbman/LIFE Picture Collection p. 16, Fernando Nieto Fotografia/Moment Open pp. 140–141, Fox Photos/Hulton Archive pp. 51, 159, Sean Gallup/Getty Images News p. 26, GlobalP pp. 136–137, GraphicaArtis/Archive Photos p. 125, GK Hart/Vikki Hart p. 99, hireo23_okubo p. 83, Hulton Deutsch/Corbis Historical p. 29, Imagno/Hulton Archive p. 12, Cesar Jodra/EyeEm p. 154, Tore Johnson/The LIFE Picture Collection p. 93, JTSiemer p. 76, Katrina Baker Photography p. 170, Keystone/Hulton Archive p. 73, Kmdgrfx p. 105, Kritina Lee Knief p. 172, Koldunova p. 50, Christina Krutz pp. 38–39, Nina Leen/The LIFE Picture Collection p. 80, John Lund/DigitalVision p. 128, MariaR p. 113, Kirstin Mckee/Moment Open p. 132, mclemay137/iStock/Getty Images Plus p. 6, Mims p. 135, Mirrorpix p. 110, Cyndi Monaghan p. 158, Mondadori Portfolio p. 116, Tuul & Bruno Morandi p. 25, Tuul & Bruno Morandi/Corbis Documentary p. 25, MRBIG_PHOTOGRAPHY p. 63, Murika p. 17, Neo Vision p. 143, Nessa p. 54, NurPhoto p. 94, Olivia ZZ p. 161, Paul Panayiotou p. 146, Radius Images p. 30, Ramaboin p. 27, Benjamin Torode p. 53, RenataAphotography/RooM p. 95, Paul A. Sanders/Corbis Documentary p. 74, Victoria Shuba/iStock/Getty Images Plus p. 45, southtownboy p. 41, Lisa Sterling p. 162, Stockbyte pp. 114–115, Tancrediphoto.com p. 56, Taro Yamasaki/The LIFE Images Collection p. 142, Jack Tinney/Archive Photos p. 82, Benjamin Torode p. 36, Kevin Vandenberghe p. 167, Vicuschka p. 8, Vintage Images/Archive Photos p. 60, Chris Winsor p. 89, Konra Wothe p. 68, YuriF/Moment p. 88; **Jenni Konrad:** p. 120; **Mark Rogers Photography:** pp. 10, 100; **Marvin Burk Photos by Rick:** p. 98; **NewsCom:** Europics p. 147, Splash News/Newscom p. 69; **Redux Pictures:** Barbara P. Fernandez/The New York Times p. 86; **Reuters:** Thomas Peter pp. 106–107; © **Shaina Fishman:** p. 156; **Shutterstock:** noreefly p. 121, Paula Piotr p. 87, Vaclav Volrab p. 91; **SWNS:** pp. 44, 112; © **Walter Chandoha:** p. 104; © **Warren Photographic:** pp. 11, 108, 109, 124, 126–127; **YouTube/romain jantot via Storyful:** p. 62; **Courtesy photos:** Cynthia Copeland p. 4; Workman Publishing: p. 40; **The Mark Twain Project, The Bancroft Library, University of California, Berkeley:** Photograph of Samuel L. Clemens with Kitten, Tuxedo Park, NY, 1907. (PH00365) p. 130.